HARVARD'S WINTHROP COLLECTION

 KU-795-260

NOT TO BE
TAKEN
AWAY

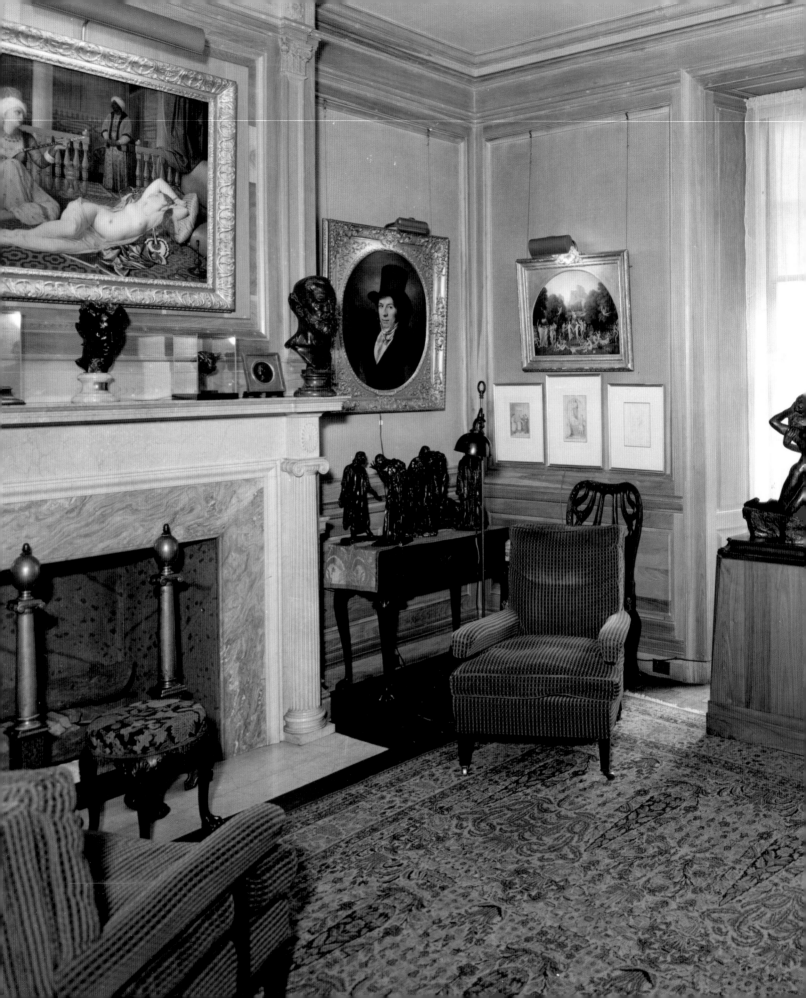

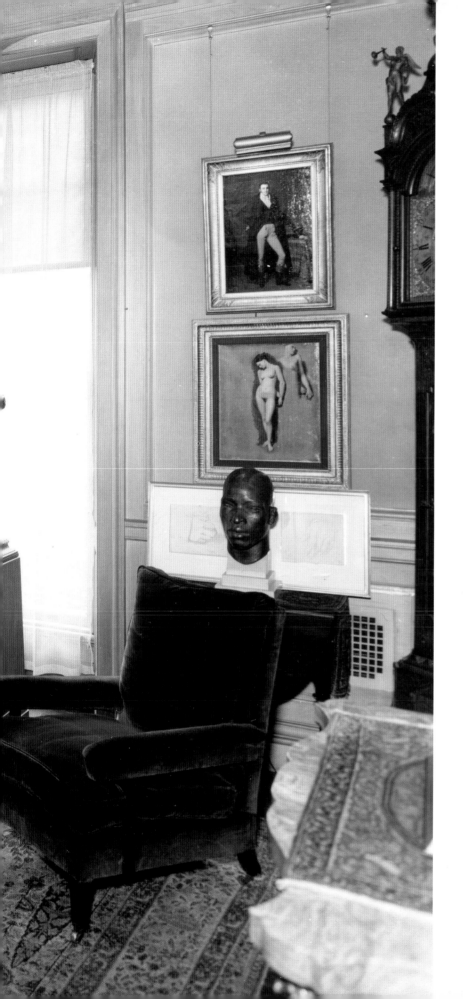

CHRISTOPHER RIOPELLE

HARVARD'S WINTHROP COLLECTION

NINETEENTH-CENTURY

PAINTINGS AND

DRAWINGS FROM THE

GRENVILLE L. WINTHROP

COLLECTION

NATIONAL GALLERY COMPANY, LONDON

DISTRIBUTED BY
YALE UNIVERSITY PRESS

This book was published to accompany the exhibition
A Private Passion: 19th-Century Paintings and Drawings
from the Grenville L. Winthrop Collection, Harvard University
at the National Gallery, London
25 June – 14 September 2003
Exhibition sponsored by ExxonMobil

© 2003 National Gallery Company Limited
All rights reserved. No part of this publication may be transmitted in any form or by any
means, electronic or mechanical, including photocopy, recording, or any storage and
retrieval system, without prior permission in writing from the publisher.

First published in Great Britain in 2003
by National Gallery Company Limited
St Vincent House, 30 Orange Street
London WC2H 7HH
www.nationalgallery.co.uk
ISBN 1 85709 920 6
525091

British Library Cataloguing-in-Publication Data
A catalogue record is available from the British Library
Library of Congress Catalog Card Number 2003007288

Publisher Kate Bell
Editor Jane Ace
Designer Peter Campbell
Picture Researcher Kim Klehmet
Production Jane Hyne and Penny Le Tissier

Printed and bound in Italy by Conti Tipocolor

Cover Illustration:
Jean-Auguste-Dominique Ingres, *The Bather*, 1808 or about 1824–33 (detail)

Pages 2–3, The 'Ingres Room' in Winthrop's house on East 81st Street, New York, 1943
Page 8, Second-floor stairwell in Winthrop's house on East 81st Street, New York, 1943
Page 12, Winthrop on his estate at Lenox, MA
Courtesy of the Harvard University Art Museums Archives
© President and Fellows of Harvard College, Cambridge, MA

All other illustrations courtesy of the Fogg Art Museum, Harvard University Art Museums
Gift of Grenville L. Winthrop, 1942–3
Photography: Katya Kallsen, except fig. 21 Peter Siegel
© President and Fellows of Harvard College, Cambridge, MA

All measurements give height before width

CONTENTS

SPONSOR'S FOREWORD

ExxonMobil is delighted to be associated with one of the highlights of the National Gallery's exhibition programme in 2003. Esso UK, an ExxonMobil subsidiary, has been supporting the National Gallery since 1988 and we are very proud of our long-standing association. This special partnership with the Gallery forms part of a wider ExxonMobil community investment programme through which we strive to support and enrich the lives of the communities in which we work. Making a positive contribution in communities wherever we do business is an important aspect of corporate citizenship.

As an American company we are especially pleased to support the National Gallery in providing the British public with the opportunity of viewing this important and innovative American collection.

This is the first time that this collection of paintings and drawings has been shown outside Harvard University's Fogg Art Museum since its bequest by Grenville L. Winthrop in 1943. Even within the United States it is little known. Therefore, most of the visitors to the National Gallery in London will not have had the privilege of seeing this spectacular collection and it will be a major revelation. We hope very much that you enjoy this once-in-a-lifetime opportunity to explore an extraordinary group of works.

ANDREW SWIGER
Chairman
ExxonMobil International Limited

Sponsored by **ExxonMobil**

DIRECTOR'S FOREWORD

As the oldest institution of higher learning in the United States, founded in 1636, Harvard University has long inspired great loyalty and generosity on the part of its alumni. Even in that large company, however, Grenville Winthrop holds a special place. The art collection he bequeathed his Alma Mater in 1943 – some 4,000 objects – is one of the most generous gifts to a museum or art gallery in American history. The collection significantly enriched Harvard's art museums by superb works ranging across 4,000 years of human history. At the same time, it allowed the museums to fulfil the mission they had already set for themselves, to educate generations of students in the fine arts by providing them with direct access to works of the highest order. The Harvard model of the teaching museum has proven widely influential, and not only in America. The Courtauld Institute of the University of London, founded in 1931 – where students also come face-to-face with great works of art on a daily basis – owes a debt to Harvard's example. Moreover, generations of British students, teachers and curators, myself included, have benefited from access to the astonishing cultural riches to be found on Harvard's campus in Cambridge, Massachusetts, and from the collegial welcome Britons traditionally receive there.

I am enormously pleased that, sixty years after his death, the National Gallery should have the opportunity to present an exhibition introducing a relatively small but vital part of Winthrop's collection to the British public. He is unique as a collector of nineteenth-century paintings and drawings in that he gave almost equal weight to the art of Britain, France and America. A visitor can readily compare the three national traditions, identify the points of contact and appreciate the contrasts. Winthrop was drawn to technical mastery in works of art and, in the exhibition, innovative artists provide virtuoso displays of skill with pencil and chalk, and in watercolour and oil paint. Winthrop preferred to collect groups of works by a relatively small number of artists. Thus, he assembled the finest Ingres paintings and drawings to be found outside France. Blake, David, Géricault, Burne-Jones, Whistler and Sargent can also be seen here in depth. This book of highlights serves as an introduction to the exhibition, and to a remarkable man who, through his generosity, has influenced museums and the teaching of art on both sides of the Atlantic.

CHARLES SAUMAREZ SMITH
Director
The National Gallery

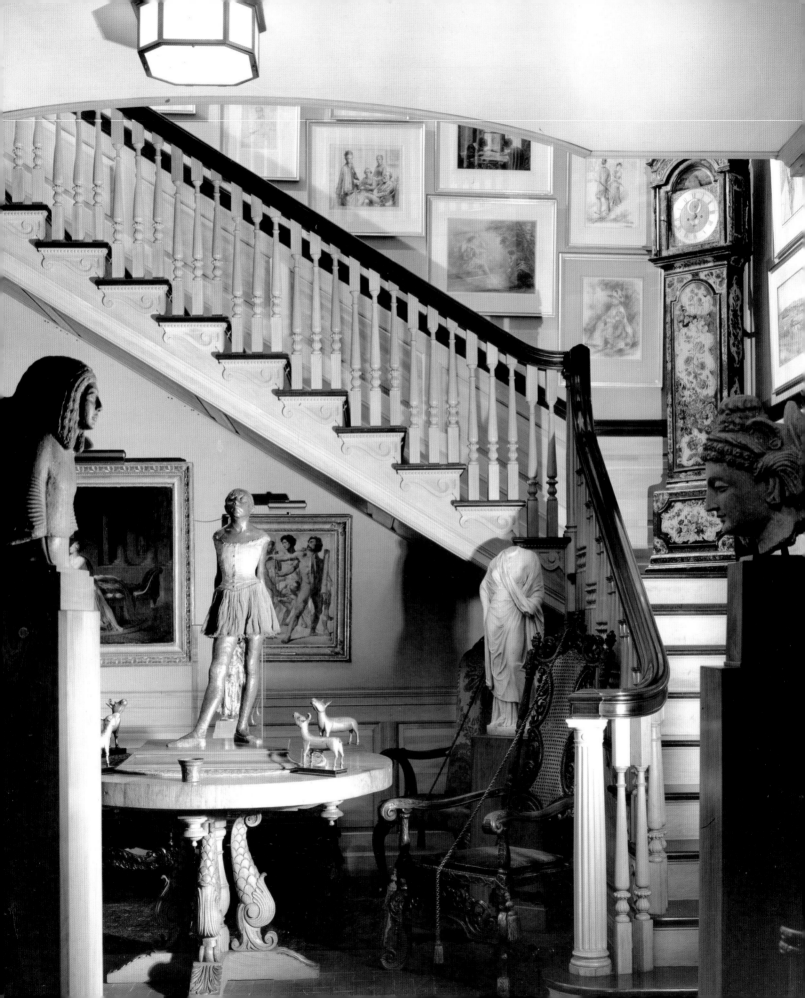

WINTHROP, HARVARD AND THE EDUCATED EYE

In 1936 Kenneth Clark, the director of the National Gallery, London, was awaiting the arrival from Paris of Jacques-Louis David's great 1817 portrait of the revolutionary polemicist, *Emmanuel Joseph Sieyès* (p. 25). He intended to present it to the Board of Trustees for acquisition; had the Trustees approved, it would have been the first David to enter the collection. But the painting never arrived in Trafalgar Square and it would be forty-eight years before the National Gallery was able to acquire a work by the artist. Only later did Clark learn what had happened. As the painting was being crated for shipment to London, the European agent for the American collector Grenville Lindall Winthrop appeared and offered the owner immediate payment. The David made its way to Winthrop's home on the Upper East Side of Manhattan instead.

The story illustrates the advantage private collectors, able to act swiftly and decisively, sometimes have over public institutions where acquisitions are made slowly by committee. More to the point, it illustrates the skill, focus and determination with which Winthrop, one of America's most assiduous art collectors, went about his business. Over some forty years, without ostentation, indeed almost without publicity, he formed one of the finest private art collections America has ever seen. In 1943 however the National Gallery's loss became Harvard University's gain when, in an all but unprecedented act of philanthropy, Winthrop bequeathed to it not only *Emmanuel Joseph Sieyès* but his entire collection of almost 4,000 art objects. The bequest included, in addition to the French, British and American paintings and drawings of the nineteenth century celebrated in this book, Old Master paintings, works of decorative art – Winthrop was particularly keen on clocks and Wedgwood – Peruvian gold and an incomparable group of archaic Chinese jades and bronzes. Long before his death, Winthrop had determined that his private passion for art would in the end assume a public role when his objects became instruments for the aesthetic education of students at America's premier institution of higher learning.

Winthrop was born in New York in 1864 into a distinguished and wealthy family of puritan stock. An ancestor had been the first governor of Massachusetts. Winthrop's father was a private banker, his mother the daughter of a banker. They moved in select society – both Edith Wharton and Franklin Delano Roosevelt's formidable mother, Sara, were family friends, J. P. Morgan a neighbour – and Winthrop, a shy lad not much given to intimacy or displays of emotion, grew up in understated Yankee ease. Like generations of (male) family members before him, he entered Harvard University in Cambridge, Massachusetts. The philosopher George Santayana and the newspaper tycoon William Randolph Hearst were in the same graduating class of 1886. The influential connoisseur of Italian Renaissance art, Bernard Berenson, who would also become a friend, was a year behind.

The decades following the Civil War were a period of enormous intellectual curiosity and expansiveness in America and Harvard was at its heart. Among the innovations there was the introduction of one of the country's earliest programmes in art history, under the professorship of Charles Eliot Norton. A friend of John Ruskin, Norton's dazzlingly erudite lectures on the nature of beauty attracted, and deeply influenced, generations of students, Winthrop among them. For

Norton: 'The purest values are always those of culture, and the pursuit of beauty is the pursuit of moral excellence.' 'I look back upon his friendship with reverence,' Winthrop later wrote of Norton, 'and upon his lectures with keen delight.' He kept the notes he had taken in Norton's lectures all his life. Some of Norton's students became important scholars, others influential museum curators and directors, and a surprising number became art collectors. Among the latter, many came to feel, like Winthrop, that they had a responsibility to give back to their Alma Mater so that the tradition of art education and the moral improvement to which it led could continue to grow. Thanks primarily to such philanthropy on the part of alumni, Harvard's art museums – there are now three: the Fogg Art Museum, the Sackler Museum and the Busch-Reisinger Museum – are today among the finest, and fullest, university museums in the world.

After graduating, Winthrop remained at Harvard to study law and then practised briefly in New York. He married and had two daughters, but by 1896, aged thirty-two, he had retired. Family members managed his affairs for the rest of his life. Henceforth, he devoted himself to the study and acquisition of art. This he pursued with intensified concentration following the death of his wife in 1900. His other interests consisted of the cultivation of austere gardens, flowerless but animated by peacocks and pheasants, at his summer home in Lenox, Massachusetts (p. 12), and the strictly sheltered, vegetarian upbringing of his daughters. Even family members had to report to him in advance on who the girls might meet when they visited. (They both later eloped on the same day, one with the electrician, the other with the chauffeur.) Early purchases of art were unexceptionable, Barbizon pictures and an important group of prints after Turner's paintings. Berenson pointed him in the direction of a few early Italian paintings, and he acquired a consuming passion for exquisitely crafted Chinese objects. A close friend, Francis Bullard, himself a collector and Norton's nephew, introduced him to the British Aesthetic Movement, and led him to concentrate in whatever he collected on the aesthetic refinement of the individual works themselves. Formal perfection and evident technical mastery became benchmark characteristics of the art he acquired.

Unusually for an American collector of his generation, Winthrop did not like to travel and rarely visited Europe. In his later years he never crossed the Atlantic. Nor did he like the hubbub of the New York art world or the notoriety of the salesroom. Although he lived across the street from the Metropolitan Museum of Art in New York, his acquaintance with staff there declined in later years and he lent only a few works of art to exhibitions in its halls. Rather, Winthrop came to rely on the advice of a few discreet dealers and Paul J. Sachs, a connoisseur and Assistant Director at the Fogg, who quietly offered sage counsel and, perhaps more importantly, kept him abreast of what was going on at his beloved Harvard. After 1914 Winthrop also turned increasingly to Martin Birnbaum, an American dealer whose extravagant and expansive personality – Charlie Chaplin was thrilled to think he might be a German spy! – was the opposite of his own. Operating out of London and Paris, Birnbaum became Winthrop's European agent – it was he who snatched away David's *Emmanuel Joseph Sieyès* from the National Gallery – in whose superb judgement about works of art the increasingly reclusive and solitary American came to have complete faith.

Birnbaum's influence on the Winthrop Collection was paramount. He first suggested to Winthrop that he concentrate on 'the collection of drawings by the salient figures of the nineteenth century'.

These were somewhat under-represented in American collections and could be acquired for reasonable prices. With Birnbaum's advice, and skilful sleuthing-out of works in private European collections, Winthrop soon expanded his interests beyond drawings to paintings of the same period. Birnbaum rekindled Winthrop's interest in the British Aesthetic Movement, and great Pre-Raphaelite paintings and drawings began to flow into the collection. It was Birnbaum too who helped focus Winthrop's attention on a relatively small number of artists whose works he could collect in depth. Thus groups of works entered the collection by Blake, Géricault, Burne-Jones, Rossetti and Moreau, among others. Urging Winthrop to acquire Géricault's *Postillion at the Door of an Inn* (p. 35), Birnbaum insisted that 'it is a work we sorely need in America'.

Most spectacularly, Winthrop and Birnbaum together assembled the finest group of works by Jean-Auguste-Dominique Ingres outside France, including such masterpieces as *Odalisque with the Slave* (p. 28), a painting of chill and crystalline eroticism of a kind that characterises many other works in the collection. More than that, steeped in the classical tradition of European art, it is painstakingly worked and meticulously finished; properties that Winthrop extravagantly admired in works of all epochs.

The collection soon outgrew Winthrop's house. In 1927 he built a townhouse on a double lot on East 81st Street to house it, limiting personal space in it to a simple bedroom for himself and another for a brother. The rest of the building, including the corridors, was given over to the display of the collection. Everything was meticulously catalogued and Winthrop spent long hours arranging and rearranging the various spaces, such as the Blake Room and the Ingres Room (see pp. 2–3), in order to incorporate new works as they arrived or to show existing works to best advantage. During these same years, some eighty miles away, in Merion, PA, a suburb of Philadelphia, Dr Albert Barnes was also rearranging his own enormous collection of nineteenth- and early twentieth-century paintings and decorative objects in just this way. In both cases it has been characterised as obsessive behaviour; but for each man finding the proper relations among his works of art was in fact a high intellectual mission, for in a harmonious grouping, methodically arrived at, each object could speak more tellingly. Like Barnes too, Winthrop was not afraid to mix together works from wildly disparate historical periods and different media in a single room, often to subtle effect.

Whereas Barnes often made access to his collection difficult, particularly if he considered a visitor too sophisticated or over-educated (and therefore blind to formal values), Winthrop made his works readily available, especially to students, and above all to students from Harvard. Groups of young art historians would come down from Cambridge on a regular basis, often accompanied by Sachs. Thus, the pedagogical possibilities of his collection, the formative impression it could make on what he called the 'Younger Generation', were strongly reinforced in Winthrop's mind.

A collection of such range and quality could not fail to attract the attention of American museum directors anxious to expand their holdings. In the 1930s overtures were made on behalf of the Metropolitan and the National Gallery of Art, Washington, DC, both hoping that the works might go there. Birnbaum for his part recommended that Winthrop open a house-museum of his own on 81st Street, on the model of Henry Clay Frick's museum further down Fifth Avenue, or Barnes's

new foundation at Merion. In any such setting, Winthrop was assured, the works of art would be available to the general public. As early as 1929, however, Winthrop had begun to think about leaving his collection to Harvard. He let it firmly be known that broad access was not his prime consideration: 'I admit that more people of the general public will visit Washington than Cambridge, but I am not so much interested in the "general public" as I am in the Younger Generation whom I want to reach in their impressionable years and to prove to them that true art is founded on traditions and is not the product of any one country or century and that Beauty may be found in all countries and in all periods, providing the eye be trained to find it.'

In 1937 Winthrop announced to Harvard's president that the collection would go there upon his death. Six years later, in 1943, it did so, but without all the attention such a benefaction might be expected to receive. Much of the world was at war and these great works entered Harvard as quietly and as understatedly as Winthrop had first collected them. To this day they are used by Harvard's students, on an almost day-to-day basis, to educate their eye and, by direct exposure to it, to learn about great art.

CHRISTOPHER RIOPELLE
Curator of Nineteenth-Century Paintings, The National Gallery

This introduction is indebted to Stephan Wolohojian's insightful essay 'A Private Passion' in the catalogue of the exhibition A Private Passion: 19th-Century Paintings and Drawings from the Grenville L. Winthrop Collection, Harvard University *(New York, 2003). Comments on individual works also are indebted to entries in this catalogue written by an international team of scholars.*

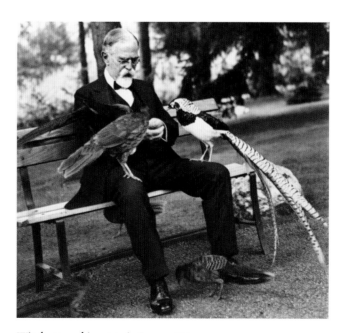

Winthrop on his estate in Lenox, MA

SELECTED WORKS FROM THE COLLECTION

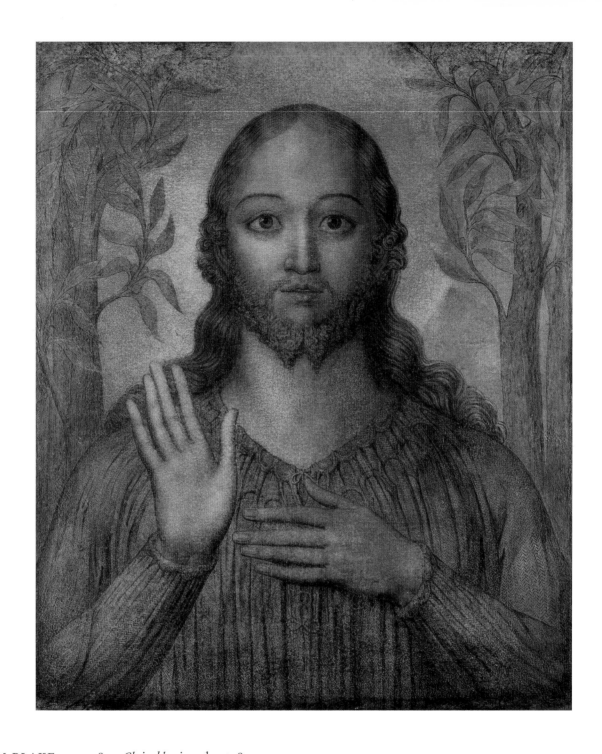

1. WILLIAM BLAKE, 1757–1827, *Christ blessing*, about 1810

Tempera on canvas, 76.5 × 63.5 cm
inv. 1943.180

Winthrop favoured relatively few artists, and collected their works in large numbers. One of the features of his New York house was the so-called Blake room where numerous drawings were displayed. At the centre of the room hung this painting of Christ, hand raised in blessing and confronting the viewer with a powerful, hypnotic gaze. It is one of a series of four works that Blake painted for an important patron, Thomas Butts, concerning Christ and Mary, and their Old Testament precursors, Adam and Eve. The series is characterised by the large figure scale and the use of a complicated tempera medium, including watercolour and glue. Blake called it 'fresco' and held that he was reviving the manner of the early Italian masters, though it bears little relation to true fresco.

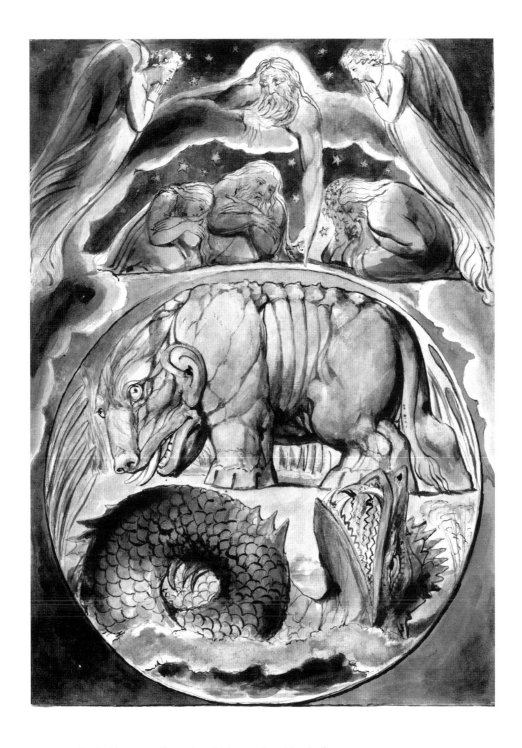

2. WILLIAM BLAKE, 1757–1827, '*Behold Now Behemoth, which I made with Thee*', 1821

Watercolour, ink and graphite on paper
27.5 × 20 cm, inv. 1943.415

The Winthrop Collection includes nineteen of the twenty-one watercolour drawings from the so-called Linnell set of illustrations to *The Book of Job*. Blake painted them on commission for the landscape painter John Linnell (1792–1882), basing them on an earlier set of illustrations dating from 1805 that he borrowed back from his patron, Thomas Butts, and made tracings from (Pierpont Morgan Library, New York). These latter drawings, more highly coloured than the first set, were later engraved and published in 1826. Here, in the fifteenth image in the series, Behemoth and Leviathan, the bestial rulers of land and sea, preside over the material world in which Job and his wife once lived before they recognised Christ. Accompanied by their Comforters, they now inhabit the starry realm above as the hand of God directs their gaze to the brutish world below.

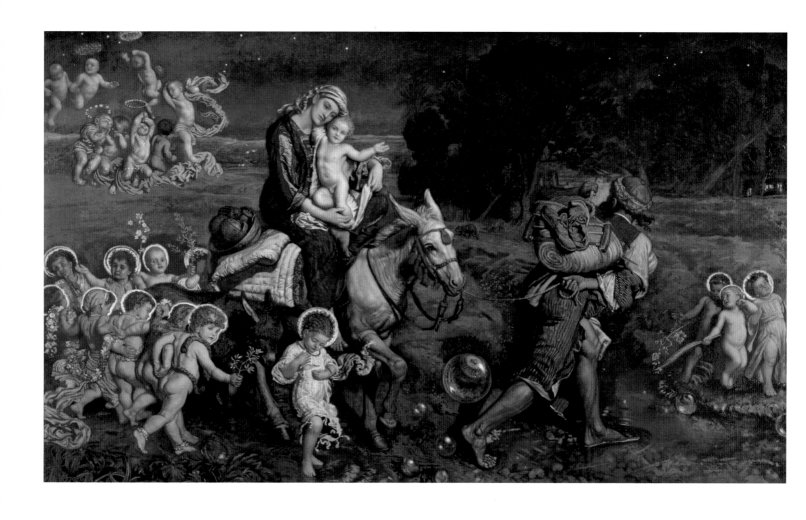

3. WILLIAM HOLMAN HUNT, 1827–1910, *The Triumph of the Innocents*, 1870–1903

Oil on canvas, 73 × 123.2 cm
inv. 1943.195

Hunt was in Palestine when he began this painting in 1870 and the moonlit landscape through which the Holy Family travels is, in Pre-Raphaelite fashion, based on close study of the local topography. Such meticulous realism is transformed,

however, by the spiritual message that the painting conveys. The Christ Child, Mary and Joseph are accompanied on their flight into Egypt by the souls of the innocent children massacred on Herod's orders. Through their sacrifice Jesus was spared so that he could die to save mankind in turn. Hunt worked on the painting for many years, completing it only in 1903 at the

behest of its first owner. He also executed two larger, rather different versions of the painting (Walker Gallery, Liverpool and Tate Britain, London); both are better known than this first version which went to Winthrop in America in 1937.

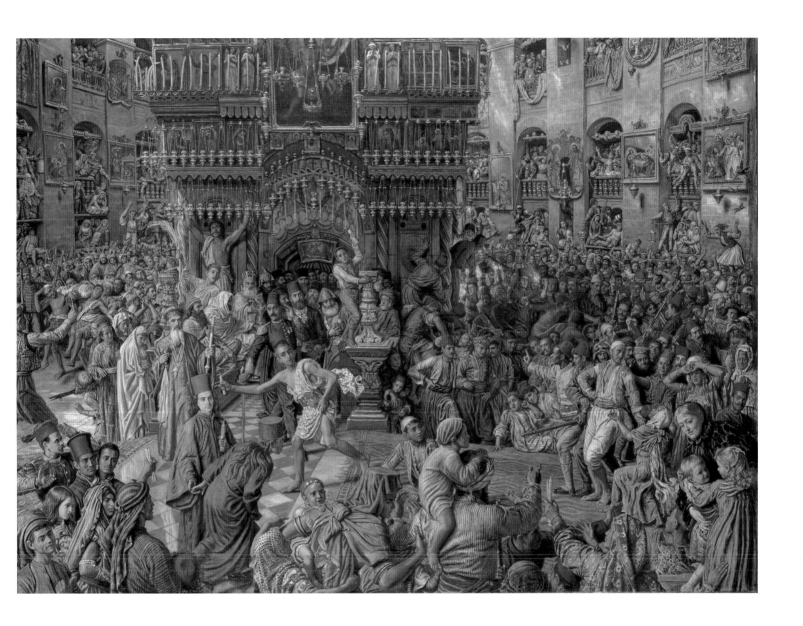

4. WILLIAM HOLMAN HUNT, 1827–1910, *The Miracle of Sacred Fire in the Church of the Holy Sepulchre, Jerusalem*, about 1892–9

Oil on canvas, 92 × 125.7 cm
inv. 1942.198

Jerusalem was for generations the site of an extravagant religious ceremony. Annually on Greek Easter Saturday, an extinguished light rekindled itself over the Tomb of Christ. Orthodox pilgrims greeted the supposed miracle rapturously, rushing forward upon seeing the flame to light candles from it, travelling with the holy objects as far as Syria and Russia. Hunt – who disapproved of all religious fanaticism of the non-English, non-Protestant variety – first witnessed the ceremony in April 1855. He saw it again in 1892 and determined to use it as the subject of a cautionary painting, which would be his last major composition. The work includes some two-hundred figures, among them the artist's wife, at lower right, in the Deborah Kerr role of the sensible Englishwoman shielding her children from foreign mayhem. The painting was completed and exhibited in 1899; despite being accompanied by elaborate explanatory texts, it met with general incomprehension.

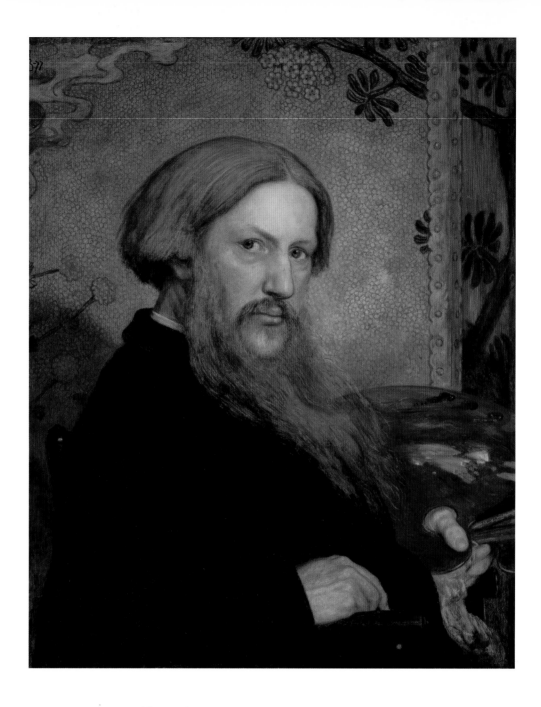

5. FORD MADOX BROWN, 1821–1893, *Self Portrait*, 1877

Oil on canvas, 74.6 × 61 cm
inv. 1943.185

The painter – palette, rag and brushes in hand – turns to confront the viewer with a steady and purposeful, if world-weary, gaze. Brown was fifty-six years old when he depicted himself here, his thick hair was grey and his beard was long. He was no longer the passionate young man dedicated to the realistic depictions of the poor and working classes, who was at the same time a close confidant of the Pre-Raphaelite Brotherhood. Rather, the portrait suggests the aesthetic interests of his later years. He is seated, in a modern wooden chair, before a tooled and painted leather screen, which is vaguely oriental in style. These objects may relate to the furniture and objects that Brown created when he worked with William Morris as a designer of furniture and textiles. That association had ended badly in about 1875 when Morris reorganised the firm and forced Brown out. In fact, Brown gave this portrait to the lawyer who represented him at that difficult time.

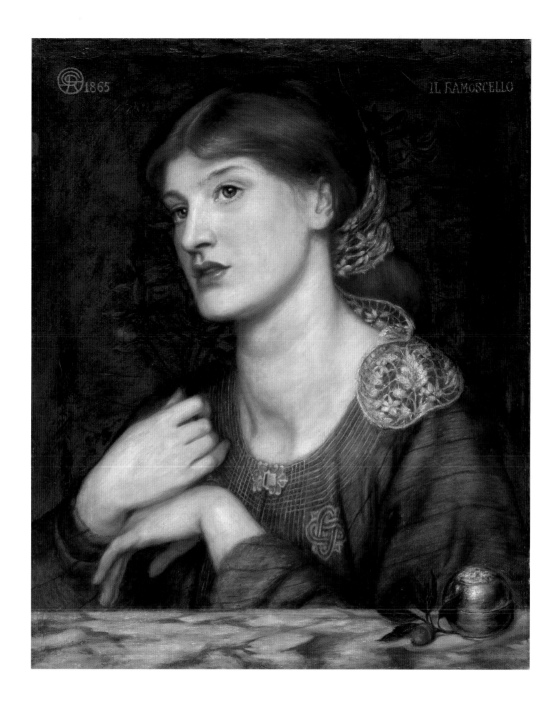

6. DANTE GABRIEL ROSSETTI, 1828–1882, *Il Ramoscello (Bella e Buona)*, 1865

Oil on canvas, 47.6 × 39.4 cm
Signed and dated upper left: DGR 1865
Inscribed top right: IL RAMOSCELLO
inv. 1943.201

In 1859 Rossetti began a long series of paintings of women. Often, as here, he showed them as half-length figures, seated behind parapets but close to the picture plane, with far-away looks on their faces as if lost in a reverie. They were not meant as portraits (although in many cases we know Rossetti's model) but as evocations of feminine beauty, not unlike the courtesan paintings of sixteenth-century Venice. Rossetti surrounded his figures with attributes suggestive of allegorical meaning. *Il ramoscello* is Italian for twig, and the woman here holds a sprig of oak. The tree symbolised fertility and regeneration for the ancient Druids, interest in whom was being revived at this time. The Celtic-style brooch at her throat also suggests that ancient Britain is being evoked. Rossetti painted the picture for a faithful patron, the manufacturer William Graham. Years later, he took it back and altered the canvas, apparently in the direction of physiognomic exaggeration. Graham did not like the result and, strong-willed like many British industrialist collectors of his day, simply had a conservator remove the artist's accretions.

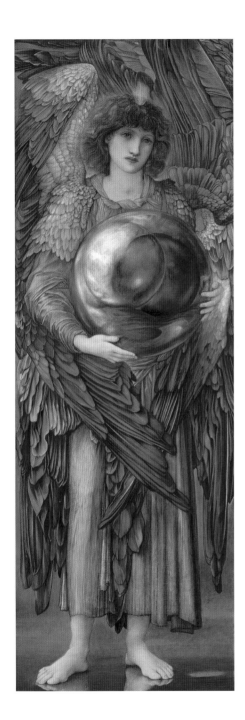

7. SIR EDWARD BURNE-JONES, 1833–1898, *The Days of Creation: The First Day*, 1875–6

Watercolour, gouache, shell gold and platinum paint on linen-covered wood, 102.1 × 36 cm
inv. 1943.454

Burne-Jones first illustrated the biblical story of the creation of the universe, as told in the Book of Genesis (1: 1–31) in 1870 in designs for stained-glass windows for a church in Northamptonshire. Several years later he undertook these large watercolour versions, remarkable for their meticulous detail and the almost fresco-like effect he achieved with a complicated mix of media. Fantastically winged, androgynous angels represent each day, one for the first day, two for the second and so on in increasingly crowded and complex images. Each angel carries a large crystal sphere within which the stage of creation can be seen. Here, on *The First Day*, the sphere shows light separating from darkness. Burne-Jones intended the series to be seen together and designed a single, enormous frame for all six panels. Winthrop, who had firm ideas on such things, jettisoned it and framed the panels separately. In 1970 *The Fourth Day* was stolen from a dining room at Harvard.

8. SIR EDWARD BURNE-JONES, 1833–1898, *The Depths of the Sea*, 1887 (Right)

Watercolour and gouache on paper mounted on wood, 197 × 76 cm
Signed and dated in gouache,
lower left: EBJ / 1887
inv. 1943.462

A mermaid drags the object of her infatuation, a naked sailor, down into her watery domain, little realising that she has already caused him to drown. Startled at the intrusion, silvery fish dart away. This was the subject of the only painting Burne-Jones ever exhibited at the Royal Academy, London, in 1886 (Private collection). The artist had borrowed a large aquarium to study watery phenomena as he worked on it, to telling effect as the president of the Academy, Frederic, Lord Leighton, praised the finished painting for its overall '*underwateriness*'. The picture was badly hung there however, and Burne-Jones resigned his Associate membership a few years later. This watercolour, painted the following year, almost exactly replicates that painting, and is almost exactly the same size. In both versions, oddly enough, the mermaid seeks to catch the viewer's eye – what, one wonders, are we doing down there? – but her expression here has been made somewhat more demure and less rapacious.

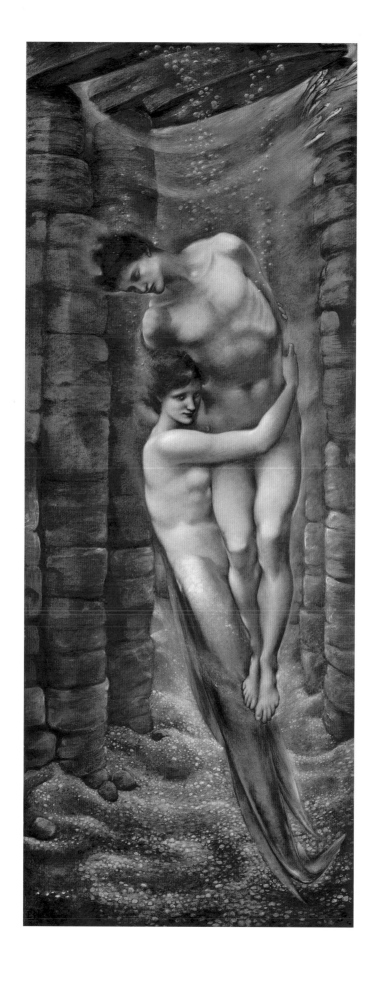

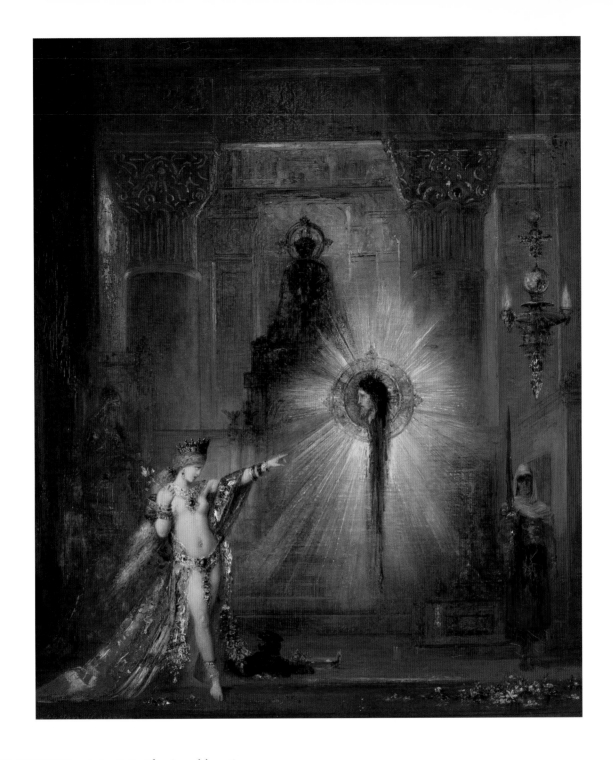

9. GUSTAVE MOREAU, 1826–1898, *The Apparition*, 1877

Oil on canvas, 54.2 × 44.5 cm
Signed lower left: Gustave Moreau
inv. 1943.268

The *femme fatale* Salome was a recurring subject of Moreau's art but here the artist imagined a scene that does not appear in the famous biblical story. A panther at her feet, she pauses in a lascivious dance before her stepfather, Herod, arrested by the bloody vision of Saint John the Baptist's severed head floating in the middle of the vast palace hall. Herod is enthroned at the left. Salome's mother Herodias, who incited her to ask for the head of John in payment for her dance, looks on, while the executioner waits at the right. The picture is a variant of a large-scale watercolour that the artist exhibited at the Paris Salon of 1876 (Musée du Louvre, Paris). Moreau painted it for a collector, Gustave Duruflé, who preferred to commission smaller versions of the artist's most famous compositions.

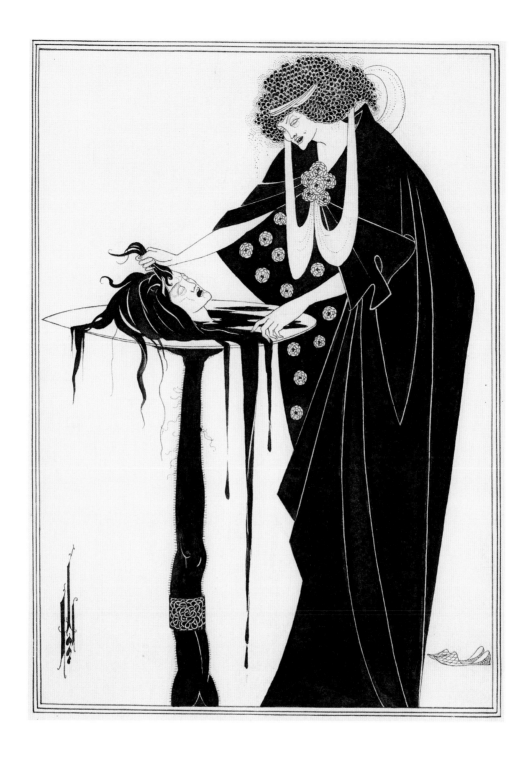

10. AUBREY BEARDSLEY, 1872–1898, *The Dancer's Reward*, for *Salome*, 1893

Ink and graphite on paper, 23 × 16.5 cm
Signed with Beardsley's Japanese monogram
in ink, lower left, inv. 1943.652

This masterfully assured ink drawing was
made as an illustration for a luxury edition
of Oscar Wilde's drama, *Salome*. The long,
muscular arm of the executioner emerges
from below bearing a charger, blood spilling
from its rim, upon which lies the decapitated
head of John the Baptist (or Iokanaan, as it is
in the play). Salome – whose prize this was
for dancing for her step-father, Herod –
clutches the hair of her victim, half in lust
and half in sorrow. Her mouth open, as is
his, she will extract from his lips the kiss the
Baptist had denied her in life. A crescent
moon curves behind Salome's head, for
Iokanaan was 'chaste, as the moon is'. Using
only black ink on white paper, Beardsley
creates an image of depravity and sensual
abandon as powerful, if not more so, than
the fantastically detailed, jewel-like canvas
of his contemporary Moreau.

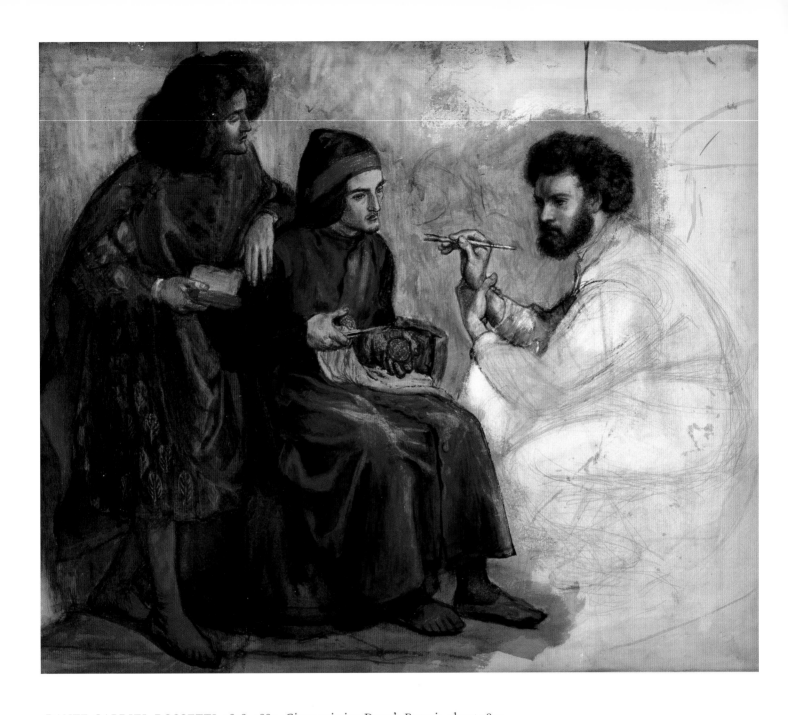

11. DANTE GABRIEL ROSSETTI, 1828–1882, *Giotto painting Dante's Portrait*, about 1859

Watercolour, gouache and graphite on paper mounted to paper-backed canvas
47.6 × 56.4 cm
inv. 1943.488

Giotto's actual portrait of Dante (Museo Nazionale del Barqello, Florence) – or at least it was presumed to be – was discovered in Florence in 1840. Rossetti soon owned a copy, and by 1849 had begun to imagine the meeting between the great Italian poet and the painter he had celebrated in his *Purgatorio*, executing drawings and paintings on the theme. The subject was of intense personal interest to Rossetti, he was named in Dante's honour and felt a passionate allegiance to him. A poet and painter, Rossetti was also fascinated by exchange among artists and between the arts. This unfinished watercolour, which may have been cut down on two sides, shows Giotto painting a fresco portrait of a youthful Dante. The poet holds a pomegranate, a symbol of immortality, while fellow-poet Guido Cavalcanti looks on with prayerbook in hand. In other versions, Cimabue, Giotto's master, and Beatrice, his beloved, swell the improbable scene.

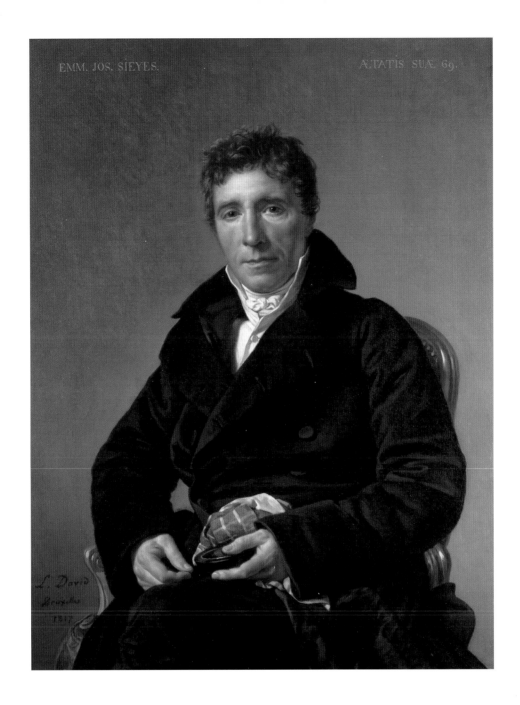

EMM. JOS. SIEYES. ÆTATIS SUÆ. 69.

L. David / Bruxelles / 1817

12. JACQUES-LOUIS DAVID, 1748–1825, *Emmanuel Joseph Sieyès*, 1817

Oil on canvas, 97.8 × 74 cm
Signed and dated lower left:
L. David / Bruxelles, 1817
inv. 1943.229

The Abbé Sieyès (1748–1836) was a priest and clerical administrator of the diocese of Chartres who became an adamant opponent of noble and clerical privilege. His pamphlet of 1789, *What is the Third Estate?*, was a seminal tract of the French Revolution and a rallying cry for sweeping reform. Sieyès went on to play an important role in the revolutionary governments of the 1790s. It was in the National Assembly that he met the painter David, himself swept up in revolutionary politics; both legislators voted for the execution of King Louis XVI in 1793. At the turn of the new century, both also became passionate supporters of Napoleon and served him in turn. With the fall of the Emperor in 1815 they were forced into exile in Brussels. There, David painted this powerful and direct portrait of his old friend. Both the format and the sobriety of the image recall David's great portraits of the 1790s. Painted when subject and painter were old men of sixty-nine, it evokes that moment a quarter century before when they withstood the gales of the revolutionary storm.

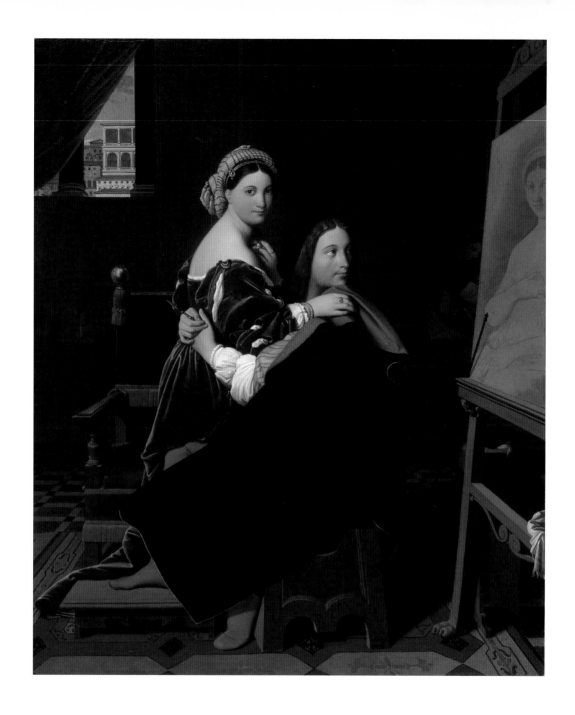

13. JEAN-AUGUSTE-DOMINIQUE INGRES, 1780–1867, *Raphael and the Fornarina*, 1814

Oil on canvas, 64.8 × 53.3 cm
Signed lower left: INGRES
inv. 1943.252

Ingres, whose early years as an artist were marked by spectacularly bad critical notices, professed admiration for Raphael (1483–1520) above all painters. In him Ingres found his ideal, for the Renaissance master was both the exemplar of the classical tradition and a struggling artist. Working in Italy but plotting his return to critical favour in Paris, Ingres devised no fewer than fourteen possible subjects for paintings based on Raphael's life. Here, Raphael sits entwined with his mistress, the poor but beautiful La Fornarina. She was reputedly the model for his *Madonna della Sedia* (Palazzo Pitti, Florence) and her pose derives from that famous painting. The *Portrait of La Fornarina* (Galleria Nazionale, Rome) can be seen on the easel. He turns from his mistress back to his unfinished panel, enacting what was for Ingres the artist's eternal struggle between the demands of life and art. Ingres sent the painting, probably the second of five versions, to the Paris Salon of 1814. One critic called it an 'imitation' of Old Master painting but others quickly appreciated that it was a striking and original kind of genre scene.

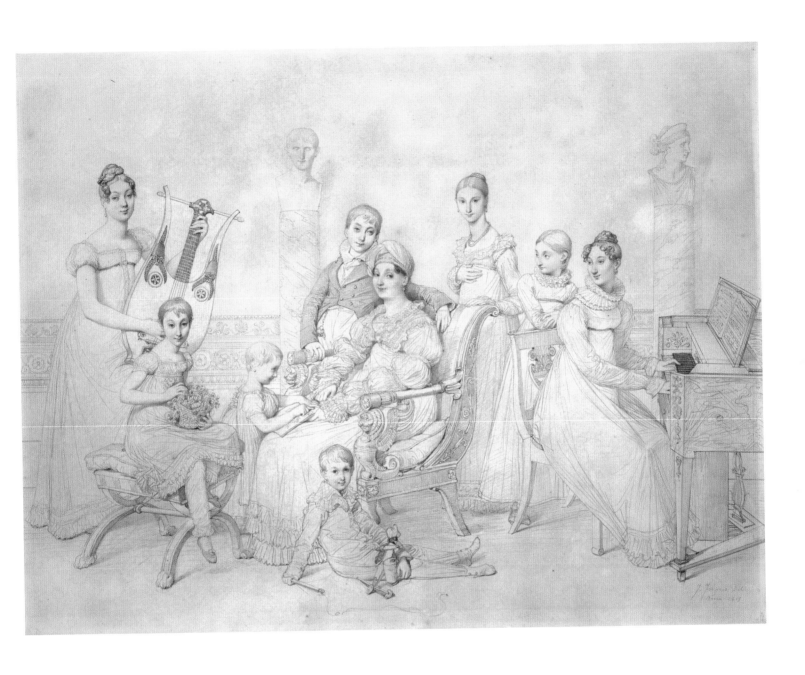

14. JEAN-AUGUSTE-DOMINIQUE INGRES, 1780–1867, *The Family of Lucien Bonaparte*, 1815

Graphite on paper, 41.2 × 53.2 cm
Signed and dated in graphite, lower right:
J. Ingres / Del [Rom, erased] / Rome 1815
inv. 1943.837

Alienated from his elder brother, the Emperor Napoleon, Lucien Bonaparte (1775–1840) lived in exile in Rome with his wife, Alexandrine, and a family that ultimately included twelve children. At the start of the Hundred Days in 1815, however, Lucien hurried to Paris to seek reconciliation with Napoleon and gain a role in the imperial administration. While he was away, his wife commissioned Ingres to make this portrait drawing, his largest and one of the most sumptuous group portraits the artist ever executed. Splendidly dressed and enthroned amidst her eight children, Alexandrine presides with calm authority. Behind her are busts of the absent Lucien, in the guise of a Roman emperor, and Lucien's mother – the matriarch of the Bonaparte clan, Madame Mère – presented as a Roman empress. Such drawings were always collaborations between artist and patron and here Ingres and Alexandrine conspire to depict her as the perfect Bonaparte wife and mother; regal, fertile and suitably respectful of the family dynasty Lucien now wished to rejoin.

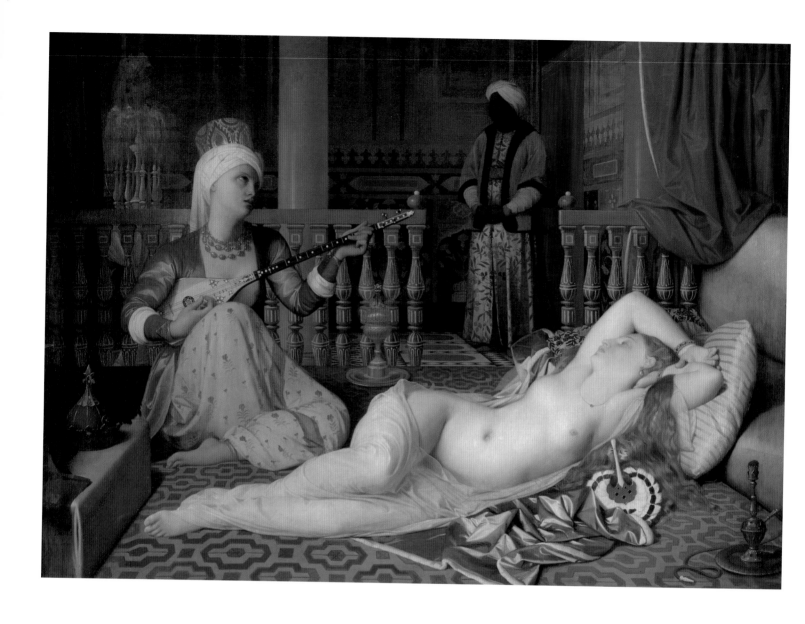

15. JEAN-AUGUSTE-DOMINIQUE INGRES, 1780–1867, *Odalisque with the Slave*, about 1837–40

Oil on canvas, 72 × 100 cm
Signed and dated lower left:
J. INGRES/ROM. 1839, inv. 1943.251

Caught up in administrative duties, Ingres painted little during his tenure as Director of the Académie de France in Rome (1835–41). One of his most important paintings from this period – completed in September 1840, although he dated it to the previous year for

unknown reasons – was this sensuous nude, a painting of refined ostentation and deep eroticism. A languorous odalisque, hookah laid aside, lapses into a dream, her body curving voluptuously toward the viewer. All the senses are evoked here: she is attended by a musician and a slave, water splashes in a fountain and a rich perfume seems to fill the air. Given over to sensuality, the odalisque is twice a prisoner; held captive in the stifling

depths of her pleasure palace and under Ingres's marmoreal painterly control. The artist's friend Charles Marcotte d'Argenteuil had commissioned the painting years before and complained at the long delay in receiving it. But it is also a public statement, Ingres's considered assessment of how the classical artist should approach the exotic oriental subject matter made popular by Romantic contemporaries such as Delacroix.

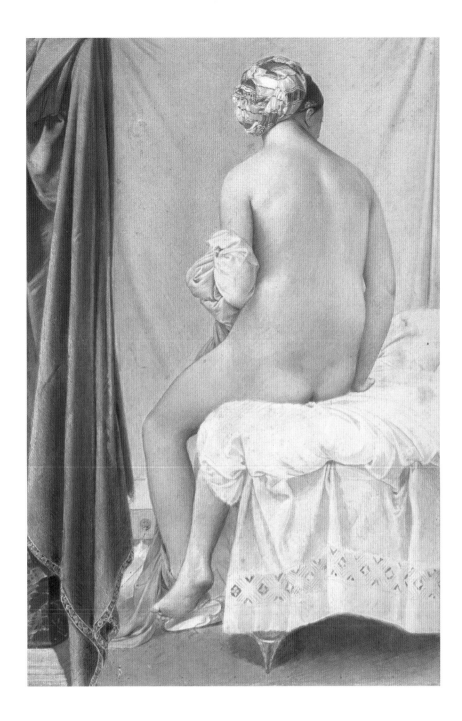

16. JEAN-AUGUSTE-DOMINIQUE INGRES, 1780–1867, *The Bather*, about 1808 or about 1824–33

Watercolour and gouache over graphite on paper, 34 × 22.8 cm inv. 1943.377

As a student at the Académie de France in Rome from 1806, Ingres was required to submit an *académie*, or painting of a nude, so that the authorities in Paris could pass judgement on his artistic progress. In 1808 he fulfilled the obligation by sending to

Paris what would become one of his most popular paintings, *The Bather of Valpinçon* (Musée du Louvre, Paris). A tender depiction of a turbaned female nude seen from the rear, the painting has a sense of intimacy and private reflection that is rare in the artist's oeuvre. This delicate watercolour is an almost exact repetition of that painting. Only small details in the contours of draperies differ from it.

Trained by his father as a watercolour painter, Ingres may well have painted the sheet, at the same time as the larger painting, as a personal record of a favoured composition – especially as he knew he might not see the original again for years. It remained in the family of his second wife, and was little known before Winthrop acquired it in 1929

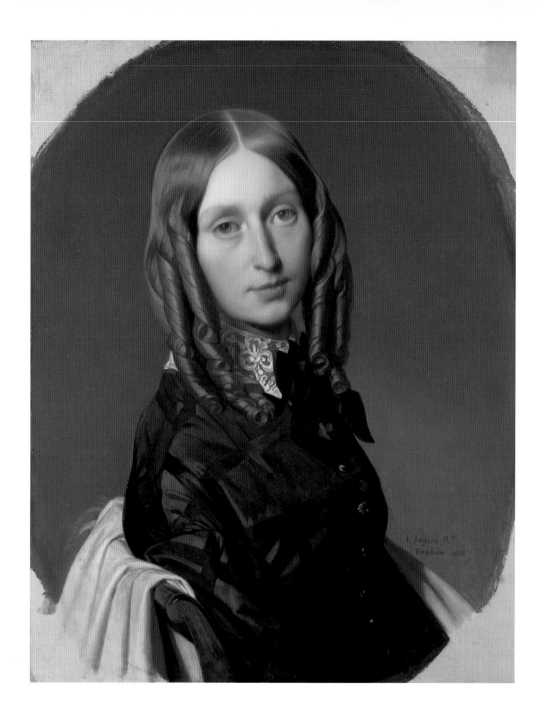

17. JEAN-AUGUSTE-DOMINIQUE INGRES, 1780–1867, *Madame Frédéric Reiset, née Augustine-Modeste-Hortense Reiset*, 1846

Oil on canvas, 59.2 × 47 cm, inv. 1943.249

Frédéric Reiset (1815–1891) was an important collector of Ingres's works and a distinguished connoisseur of drawings who ultimately became director of the Musée du Louvre between 1874 and 1879. He married his first cousin in 1835. After meeting Ingres on their honeymoon in Rome, the young couple became trusted friends of the artist. In later years, Ingres often visited the Reiset home at Enghien in northern France – he called it a 'paradise' – and retreated there to mourn the death of his first wife in 1849. Beginning in 1844, Ingres executed five drawings of members of the family. Two years later, he painted this simple and direct portrait of Madame Reiset (1815–1893) at her husband's request. The sitter, dressed modestly, though with luxuriant blonde curls spilling over her shoulders, turns to face us with an even, affectionate gaze, the hint of a smile playing across her lips. The picture shares the sense of easy intimacy and lack of ostentation that Ingres reserved for depictions of only his closest friends and loved ones.

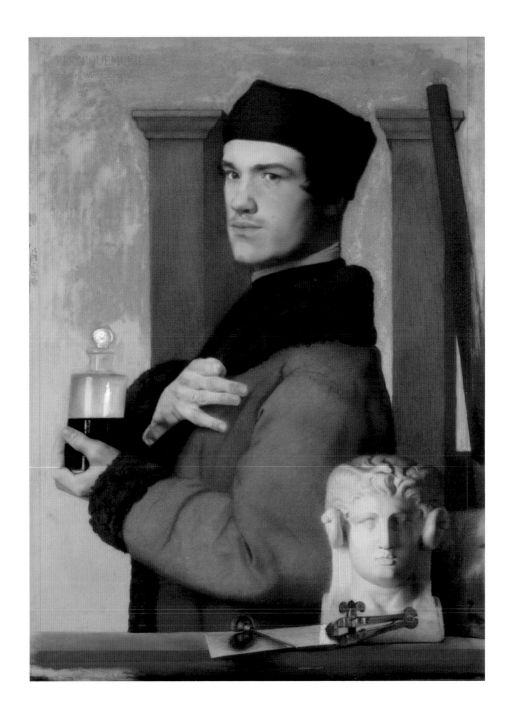

18. FÉLIX-AUGUSTE-JOSEPH BRACQUEMOND, 1833–1914, *Self Portrait*, 1853

Pastel, graphite and paint on paper,
92.9 × 68.2 cm
inv. 1943.836

Bracquemond was an innovative printmaker, and largely a self-taught one, whose etchings and engravings are bravura performances of technical skill. He was also an important early populariser of Japanese prints and an admired designer of exquisite decorative objects. He knew everyone in artistic and literary Paris. Even as a young man – and he was only twenty years old when he produced this remarkably assured self portrait – Bracquemond was a virtuoso master of his medium. Not content to portray his features modestly, he worked here on a large scale, presenting himself for our appreciation as if he were a proud sixteenth-century Renaissance master. The influence of Holbein can be seen in the linear precision of the artist's draftsmanship, his knowing use of attributes and in the air of supreme self-confidence that pervades the sheet.

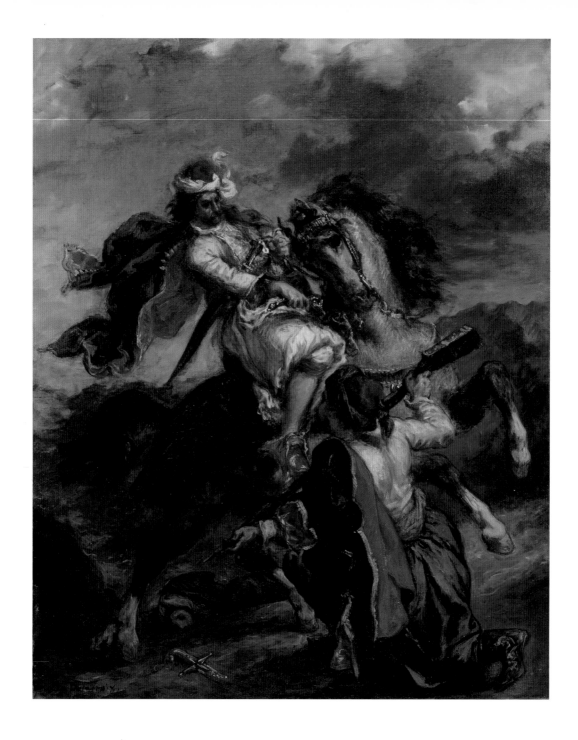

19. FERDINAND-VICTOR-EUGÈNE DELACROIX, 1798–1863, *A Turk surrenders to a Greek Horseman*, 1856

Oil on canvas, 80 × 64.1 cm
Signed and dated lower left:
Eug. Delacroix / 1856
inv. 1943.233

His scimitar flung to the ground, a Turk kneels in submission before a mounted Greek. The subject immediately evokes the Greek War of Independence (1821–32), a conflict in which Delacroix, like many of his Romantic contemporaries, passionately supported the Greek cause. The picture was also long thought to illustrate an episode from Lord Byron's 'oriental' poem, *The Giaour* (1813), since Delacroix had already painted the subject in 1826 and 1834. In fact, it may well allude to both themes, and also incorporate reminiscences of the artist's visit to Morocco in 1832. The rich colours and exoticism of north Africa profoundly influenced his art. Like this painting, some of Delacroix's most vivid 'orientalist' works are those done late in life, when he gave free rein to his memory of favourite sites, poems and earlier paintings, and became fearless in the intensity of his palette.

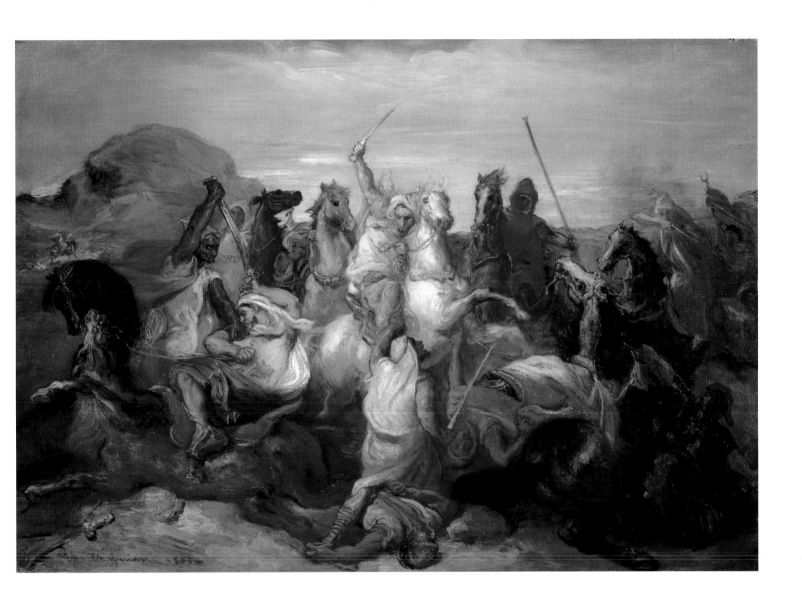

20. THÉODORE CHASSÉRIAU, 1819–1856, *Arab Battle* or *Battle of Arab Horsemen*, 1855

Oil on wood, 31.75 × 45.72 cm
Signed and dated lower left:
Th^re. ChasSériau 1855
inv. 1942.190

Chassériau spent two months in Algeria, in 1846. There he accumulated deeply-felt experiences of an exotic world, and made numerous studies of human and animal figures, on both of which he would draw in later years. Almost certainly he never witnessed a ferocious military battle such as he depicted here, between Arabs, known as Kabyles, and Spahis, as the native soldiers recruited by the French were called. It is a work of imagination, assembled from what the artist had seen and sketched nine years earlier, and on a veritable arsenal of Arab armaments he collected in his studio. The scene is also informed by his knowledge of a long tradition of battle painting in European art, stretching back to Leonardo's lost *Battle of Anghiari* and to works by another of his artist heroes, Rubens. These twin sources, art and experience, account for the baroque sweep of the composition and the high realism with which individual details are rendered.

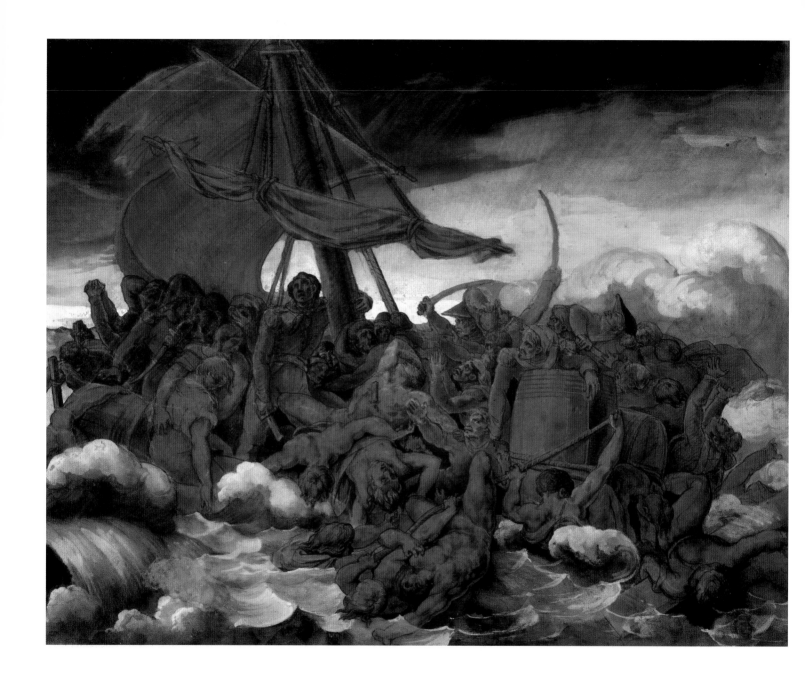

21. JEAN-LOUIS-ANDRÉ-THÉODORE GÉRICAULT, 1791–1824, *The Mutiny on the Raft of the Medusa*, 1818

Chalk, crayon, watercolour and gouache on paper, 40.5 × 51 cm inv. 1943.824

The sinking of the French frigate *Medusa* off the west coast of Africa in 1816, and the tragic fate of those abandoned to drift at sea on a raft for thirteen days, was perceived as evidence of official French indifference and caused a press sensation and a political scandal. Géricault determined to make it the subject of an ambitious large painting for which he laboriously prepared, finally exhibiting it at the Paris Salon of 1819. That work (Musée du Louvre, Paris) depicts the survivors' first sight of their rescue ship, but Géricault also experimented with other, more harrowing moments in the ordeal. In this highly-wrought, sweeping and intensely dramatic sheet, he depicts a sailors' mutiny. Amid turbulent seas, swords flash, one officer clings to the mast and twisting, tormented nude figures, reminiscent of Michelangelo's, spill from the makeshift craft.

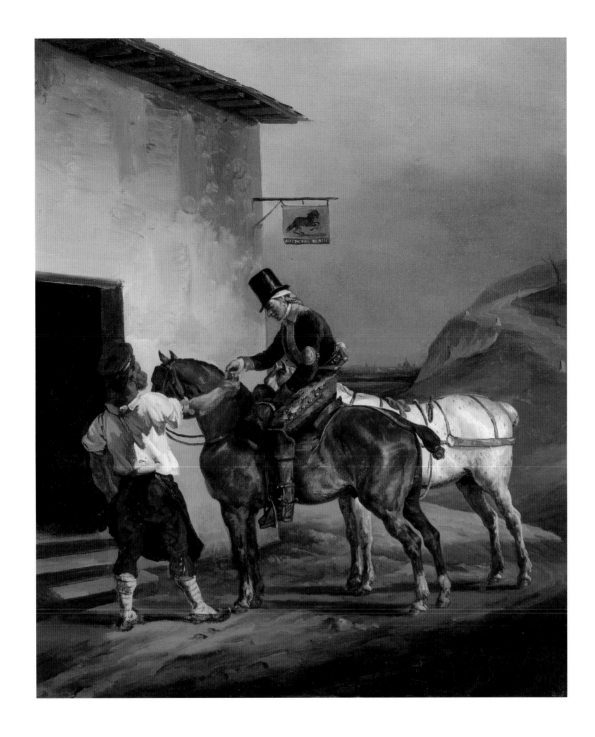

22. JEAN-LOUIS-ANDRÉ-THÉODORE GÉRICAULT, 1791–1824, *Postillion at the Door of an Inn*, 1822–3

Oil on canvas, 53.3 × 45 cm, inv. 1943.244

The uneventful scene is set on the outskirts of Paris; the city's domes and spires can be seen in the distance. A traveller has stopped at an inn, *Au Cheval Blanc*, and the innkeeper hands him a welcome glass of wine before he continues on his journey. In its simplicity, directness and close observation of everyday human interaction, the picture is a testament to the impact that British art had on Géricault's imagination. He visited England in 1820–1, exhibiting his monumental and grandiloquent canvas of 1819, *Raft of the Medusa* (Musée du Louvre, Paris), to paying customers in Piccadilly Circus. At the same time, Géricault acquainted himself at first hand with the works of modern British artists including John Constable and especially David Wilkie, whom he met and whose naturalism and affection for humble motifs and figures he admired. Henceforth, Géricault's own works turned increasingly towards more unassuming subjects as well.

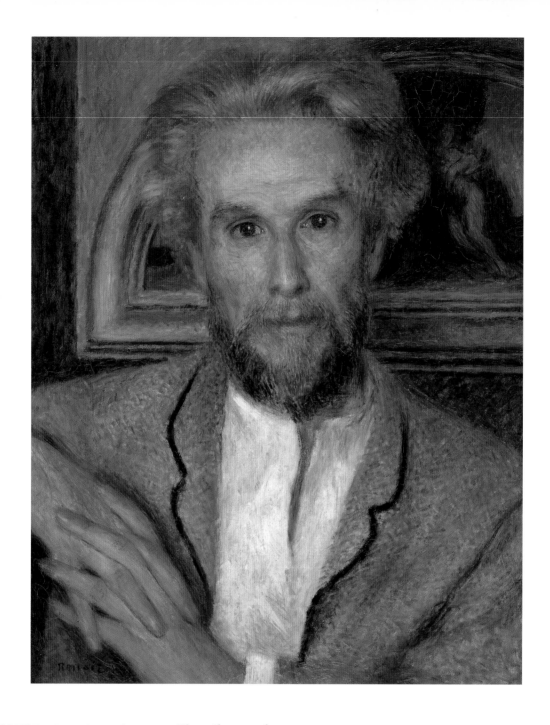

23. PIERRE-AUGUSTE RENOIR, 1841–1919, *Victor Chocquet*, about 1875

Oil on canvas, 53.02 × 43.5 cm
Signed lower right: RENOIR
inv. 1943.274

Victor Chocquet (1821–1891) was an indefatigable art collector, though not a wealthy one, haunting the Paris dealers and filling his apartment with paintings, fine furniture and *objets d'art*. His favourite painter was Delacroix, but in the 1870s he was among the first to admire and collect the young Impressionists, including Cézanne and Renoir. He saw the latter as Delacroix's natural successor as a modern master of colour. Thus, when Renoir came to paint the portrait of this odd, passionate man, he placed Chocquet in front of one of his Delacroix paintings, a study for a mural on a mythological theme. Chocquet's explosion of grey hair wittily echoes the lunette shape of the Delacroix painting, while his long, meditative face is dominated by piercing blue eyes. Renoir was fond of the man, remarking of one of his portraits of Chocquet that it was 'of a nut … by a nut!'

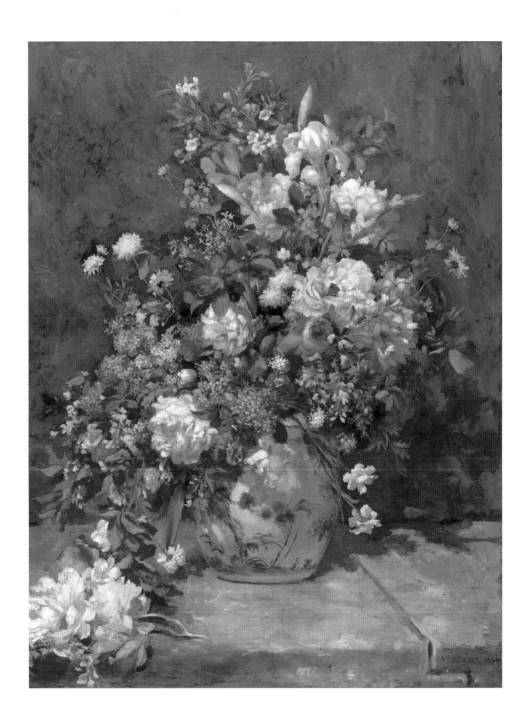

24. PIERRE-AUGUSTE RENOIR, 1841–1919, *Spring Bouquet*, 1866

Oil on canvas, 104 × 80.5 cm
Signed and dated lower right: A. RENOIR 1866
inv. 1943.277

Renoir painted this still life of spring flowers in an elegant blue-and-white Chinese vase, in the early summer 1866. At about the same time, he painted a more rustic still life showing wildflowers haphazardly displayed in a simple earthenware pot (National Gallery of Art, Washington, DC). Both were destined for the architect Charles Le Coeur (1830–1906), Renoir's earliest and most loyal patron. The latter work may have hung in the family's country home. On the other hand, a photograph of the early twentieth century shows this painting hanging in the Le Coeur's grand Parisian home, flanked by actual Chinese vases. It is as if the two canvases were conceived as pendants contrasting the simplicity of the countryside with urban refinement. During his early years, flower painting played an important role in Renoir's artistic development. As he told a critic, 'I just let my mind rest when I paint flowers. … I establish the tones, I study the values carefully, without worrying about losing the picture. … The experience which I gain in these works, I eventually apply to my [figure] pictures.'

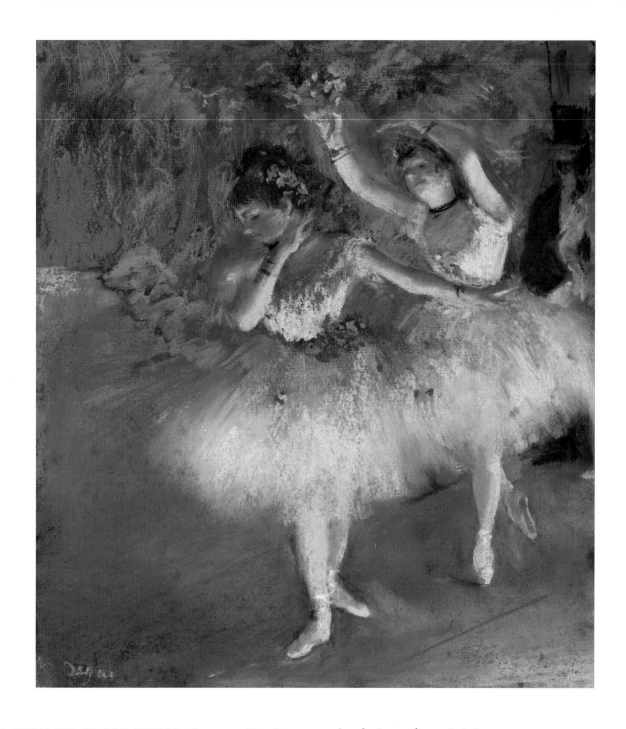

25. HILAIRE-GERMAIN-EDGAR DEGAS, 1834–1917, *Two Dancers entering the Stage*, about 1876–8

Pastel over monotype print
38.1 × 35 cm
Inscribed in chalk, lower left: Degas
inv. 1943.812

From the early 1870s Degas became obsessed with the world of ballet in Paris, recording dancers, dance instructors, musicians and audience in paintings, drawings, monotypes, pastels and sculptures. During his lifetime they were, as they remain, among the artist's most popular works. Here, two dancers have just passed the scenery flats at stage left and entered into the glare of limelight and public view. Behind them, a third dancer – we see her jutting elbow and the flair of a tutu – prepares to rise *en pointe* and follow them on stage. In the background, a top-hatted *abonné*, or wealthy ballet subscriber who could gain admission backstage, eyes the young girls with perhaps more than aesthetic interest. Here, brilliant pastel is laid over a 'dark field' monotype print (although no other impression is known). The gentleman in the wings, however, is an improvisation by Degas, added in pastel alone.

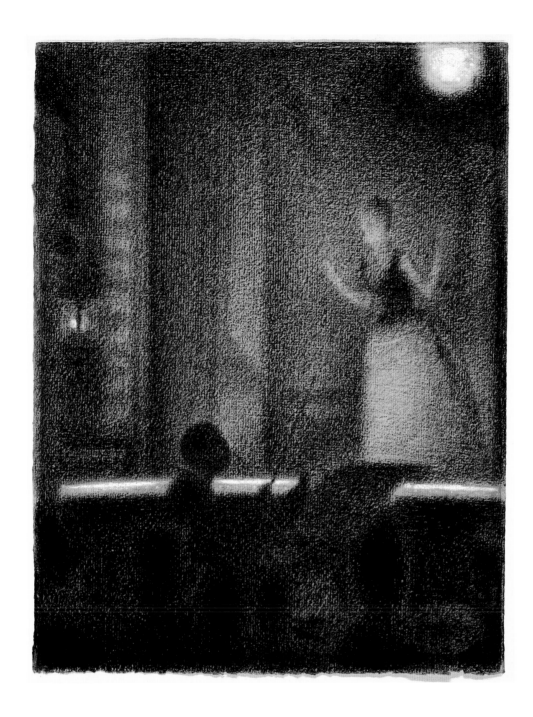

26. GEORGES-PIERRE SEURAT, 1859–1891, *Café-Concert (À la Gaîté Rochechouart)*, 1887–8

Conté crayon and gouache on paper
30.7 × 23.4 cm
Signed top centre: G. Seurat
inv. 1943.918

Like his older contemporaries, Manet and Degas, Seurat was drawn to scenes of leisure and public entertainment in modern Paris, including popular music concerts in the city's cafes. He exhibited this depiction of one such venue in 1888. Unlike Manet and Degas however, Seurat's was not an art of impressionistic naturalism. His depictions are highly stylised, structured with mathematic precision and seemingly frozen in time. Early in his brief career, he had devised a distinctive graphic manner, executing drawings by rubbing black chalk across the surface of grainy paper. Blank areas of paper, some heightened with gouache, establish the highlights, against which expressive details, such as the profile of the conductor at the lower left, are rendered in thick black crayon. The arms and face of the singer herself seem to be illuminated by stage light. Such works are infinitely subtle and calculated explorations of the expressive possibilities that Seurat found in the contrast of black and white, and in the nuances of tone that lie between.

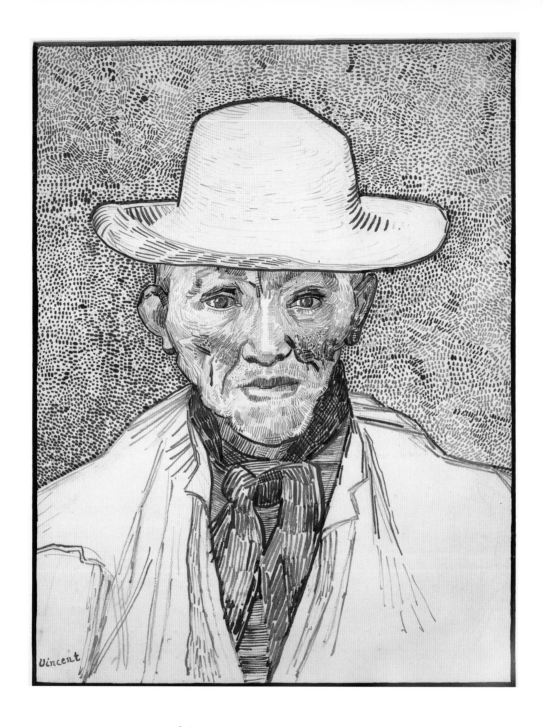

27. VINCENT VAN GOGH, 1853–1890, *Peasant of the Camargue*, 1888

Ink over graphite on paper, 49.4 × 38 cm
Signed in ink, lower left: Vincent
inv. 1943.515

Van Gogh relocated from Paris to the Provençal town of Arles early in 1888. There he waited for Paul Gauguin to join him in October. Together they would briefly establish the Studio of the South of which Van Gogh had long dreamed. During the

summer, Van Gogh, working alone, enjoyed one of the most prolific and inventive periods of his career, painting the landscape in and around Arles and the peasants he met there. Among them was Patience Escalier from the Camargue whose rustic directness Van Gogh admired and whom he compared to a peasant from a painting by Millet. Van Gogh painted Escalier's portrait twice, and also made this portrait drawing. Like the sky

in certain landscape drawings also executed in July and August 1888, the background here is animated by countless tiny ink dots. They show the influence of Georges Seurat's Pointillist painting style with which Van Gogh had briefly experimented in Paris. At the same time, they suggest the intensity with which the artist confronted the new subjects he was discovering in the south.

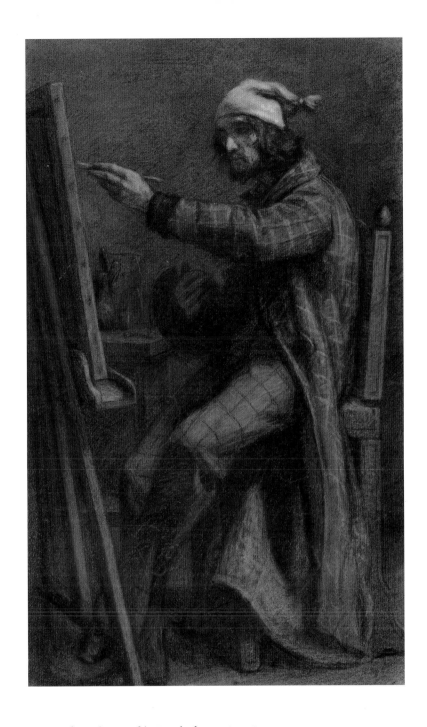

28. GUSTAVE COURBET, 1819–1877, *The Painter at his Easel*, about 1847–8

Chalk, charcoal and graphite
on paper, 55.4 × 33.5 cm
inv. 1943.787

Courbet was an infrequent draftsman. This large chalk drawing is one of relatively few sheets by him, most dating from early in his career. He was, however, a prolific self-portraitist, primarily in oil paint on canvas, and especially in those same early years as he attempted to define an artistic persona and establish his reputation. He said of such self-conscious images, 'I have written my life'. Here, Courbet depicts himself as a struggling artist: thin, wiry, intense, and resolutely focused on his art. Bundled up against the cold in his garret studio, he sits before an easel upon which a stretched canvas rests, ready to attack it with his brush. This was not simply a bohemian pose – or not only that – for Courbet's financial resources were meagre at the time. The sheet is a masterly exercise in the control of light and shade. It is a finished drawing, rather than a preparatory study, and Courbet included it in a famous one-man exhibition in 1855.

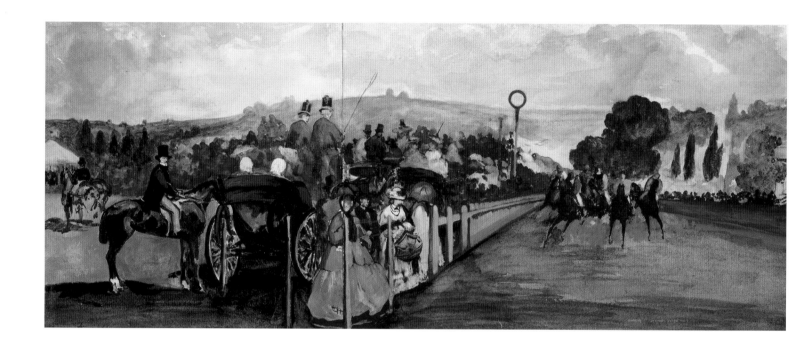

29. ÉDOUARD MANET, 1832–1883, *Racecourse at Longchamp*, 1864

Watercolour and gouache over graphite
on two sheets of paper, 22.1 × 56.4 cm
inv. 1943.387

Manet was committed to depicting modern
Paris life, and to discovering novel modes of
representation to evoke its rapid pace and
sense of constant change. In 1864 he painted
a large canvas showing a horse race at the
fashionable Longchamp racecourse in the
Bois de Boulogne. That work was cut up the
following year and all trace of it has
disappeared. This watercolour, a painting of
1866 (Art Institute of Chicago), and a later
lithograph, each one successively freer and
more spontaneous in execution, record
aspects of the lost work. Its twin themes are
speed and danger. The artist audaciously
places himself in harm's way at mid-track as
the horses thunder towards him. They have
just passed the finish line, marked by a grey
pole topped by an open circular disc, but
show no sign of lessening their pace. The
track is lined by elegant bystanders, and the
sense of movement that dominates the right
side of the sheet is thrown into relief by the
figure of an elegant gentleman at the far left,
astride a horse that stands perfectly still.

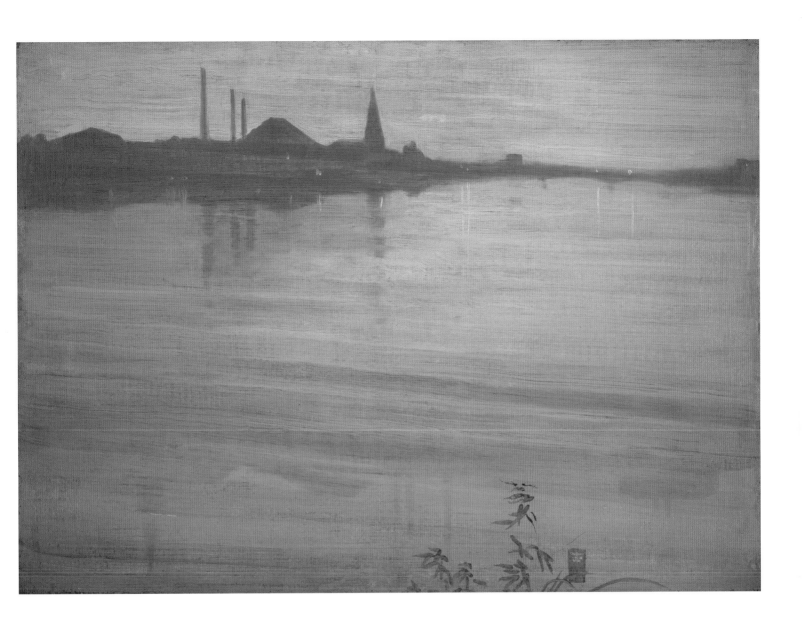

30. JAMES ABBOTT MCNEILL WHISTLER, 1834–1903, *Nocturne in Blue and Silver*, about 1871–2

Oil on wood, 44.1 × 61 cm
inv. 1943.176

This may be the only work of art in the Winthrop Collection to have played a role in a court trial. It was submitted as evidence in Whistler's famous November 1878 libel suit against the critic John Ruskin for calling one of the artist's *Nocturne* paintings 'a pot of paint flung in the public's face'. (Whistler won the suit but it ruined him financially.) Ruskin objected to the haphazard nature of the images, seemingly without substance or structure. In fact, the *Nocturnes*, with their thin veils of colour and minimal detail, are among Whistler's most daring formal innovations. Painted quickly, often in the course of a single day, these views of the Thames in evening light were also often painted from memory, in order to capture the essence of a view rather than its mundane specifics. Here, Whistler depicts London's Battersea Reach as seen from his own house at Lindsey Row. The spire of Battersea Church can be made out, but the most prominent motif on the far shore is the slagheap of a lead factory. The panel is signed at the lower right with the artist's distinctive butterfly device.

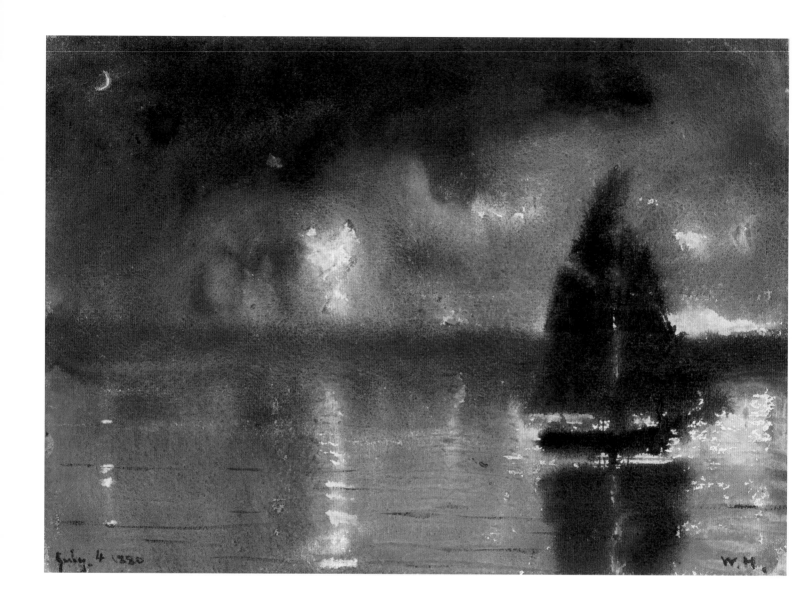

31. WINSLOW HOMER, 1836–1910, *Sailboat and Fourth of July Fireworks*, 1880

Watercolour and gouache on paper
24.5 × 34.7 cm
Inscribed lower left: July 4 1880
Lower right: WH, inv. 1943.305

Homer spent the summer of 1880 at Gloucester, a fishing village on the Atlantic coast of Massachusetts. He lived in a lighthouse overlooking the harbour and, on the Fourth of July, after a long day of concerts, boat races and general merriment, had an excellent view of the fireworks display that traditionally brings festivities to a close on this most patriotic and popular of American holidays. As the rockets arced in the night sky, their luminous trails reflected in the water, Homer quickly captured the scene using liquid washes of inky watercolour and quick touches of white gouache. A sailboat, making its way back to dock, is silhouetted against the fiery sky while, at the upper left, a crescent moon casts its own reflections on the water. This dazzlingly economical sheet reveals Homers' growing appreciation of the pictorial possibilities of Impressionism, and of the art of his countryman Whistler.

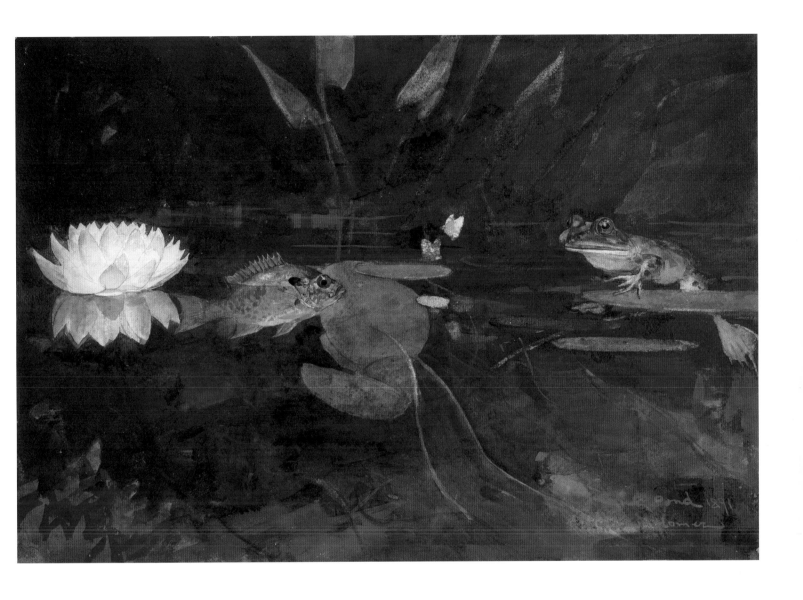

32. WINSLOW HOMER, 1836–1910, *Mink Pond*, 1891

Watercolour over graphite on paper
35.2 × 50.8 cm
Inscribed in gouache, lower right:
Mink Pond 1891 / Winslow Homer
inv. 1943.304

From early in the nineteenth century the lakes and forests of the Adirondack Mountains in upper New York State offered a retreat from urban American life. Homer often went there and at Mink Pond he found a favourite spot for fishing, to which he was devoted, and painting, primarily in watercolours. Here, the artist minutely examines a small corner of the pond. It teems with life, underwater and above, and the limpid, still water allows him to depict both environments with crystalline clarity. A water lily casts a perfect mirror image. Long tendrils of plants snake though the water below while reeds sprout on the muddy bank above. Most remarkable, a sunfish pokes though the surface and coolly appraises a frog seated on a lily pad, one leg dangling in the water. Pure and unspoiled, this is an image of timeless American innocence and Homer is the awed observer of a peaceable kingdom.

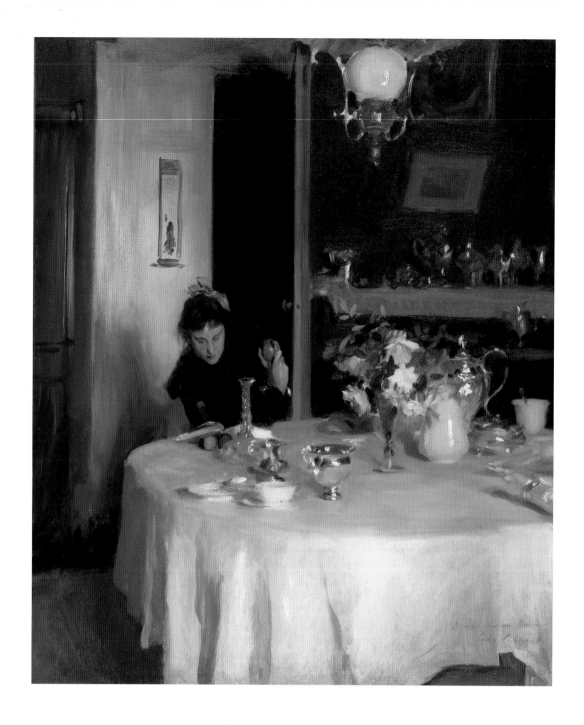

33. JOHN SINGER SARGENT, 1856–1925, *The Breakfast Table*, about 1883–4

Oil on canvas, 53.98 × 45.09 cm
Signed lower right: John S. Sargent
Inscribed lower right:
à mon cher ami B[esnard]
inv. 1943.150

Sargent's facility with a paintbrush, whether he was working in watercolour or oil paints, was prodigious. Seemingly effortlessly, his swiftly moving brush evoked textures in cloth, the gleam of light on metal, forms emerging out of shadows, overlapping planes and complex spaces. Here, he depicts his younger sister, Violet, sitting down to her breakfast, but hardly able to prise her eyes from the book she reads – perhaps a new French novel. The picture was painted at their parents' house at Nice in the south of France and morning light floods in to splash across the tablecloth. Many artists in the late nineteenth century cultivated the bold painting technique for which Sargent was famous, the Swede Anders Zorn and the Spaniard Joaquin Sorolla among them. So too did Sargent's friend, the Frenchman Albert Besnard (1849–1936). Perhaps one artist was showing off to another when Sargent inscribed and presented this glowing canvas to Besnard as a gift.

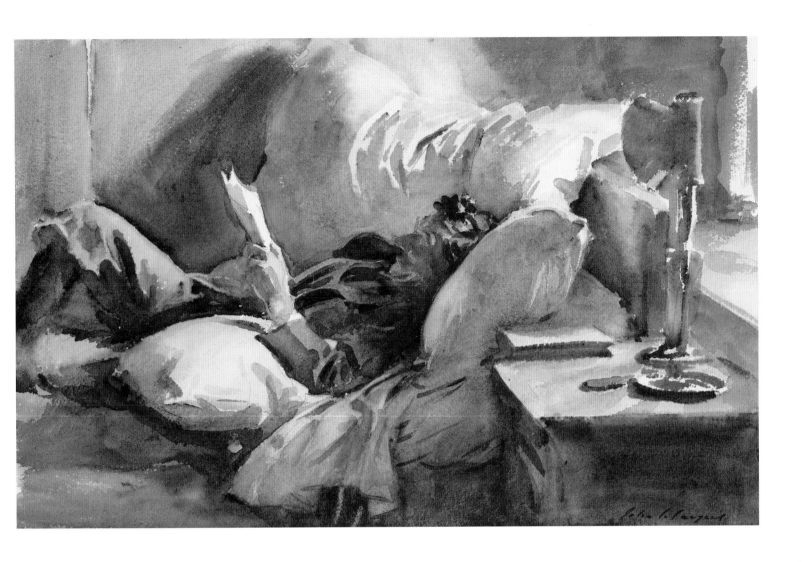

34. JOHN SINGER SARGENT, 1856–1925, *Man reading*, about 1904–11

Watercolour over graphite on paper
34.9 × 53.5 cm
Signed lower right: John S. Sargent
inv. 1943.315

A man leans back into a pile of plump pillows, a sheaf of papers in his hand. Sargent was a watercolour virtuoso and, particularly in his later years after he gave up painting commissioned portraits in 1909, often exploited the medium to capture swift and vivid vignettes of friends and acquaintances at moments of relaxation, indoors and out. It is not certain who is depicted here. Light glints in his dark hair as it falls on the bed from a table-top lamp, but his facial features are muted, while the complicated shadows cast by the pillows are subtly rendered. Sargent's watercolours were widely admired in turn-of-the-century America, with major museums including Boston, Brooklyn and the Metropolitan in New York collecting them almost in bulk. Winthrop too brought together a small but superb representative selection.

FURTHER READING

Bowron, *European Paintings Before 1900 in the Fogg Art Museum*
Cambridge MA, 1991

Cuno et al., *Harvard's Art Museums: 100 Years of Collecting*
Cambridge MA, 1996

Mortimer, *Harvard University Art Museums: A Guide to the Collections*
New York, 1986

Wolohojian et al., *A Private Passion: 19th-Century Paintings and Drawings from the Grenville L. Winthrop Collection, Harvard University*
New York, 2003